SAUGATUCK & DOUGLAS

Hand-Altered Polaroid Photographs

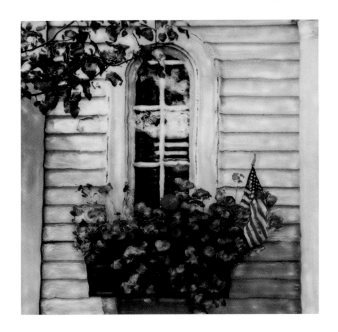

Cynthia Davis

THE UNIVERSITY OF MICHIGAN PRESS ANN ARBOR

Copyright © by the University of Michigan 2004
Photographs copyright © Cynthia Davis 2004
All rights reserved
Published in the United States of America by
The University of Michigan Press
Manufactured in Singapore
♾ Printed on acid-free paper

2007 2006 2005 2004 4 3 2 1

A CIP catalog record for this book is available from the British Library.

U.S. CIP data applied for.

ISBN 0-472-11440-9

Special thanks to the Saugatuck/Douglas District Library.

This book is dedicated to my mother,
Lorena Davis

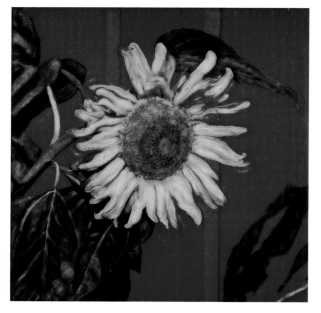

She indulged and abetted my interest in art throughout my childhood and beyond. In her late fifties she began painting and became quite accomplished at watercolor. She would have loved the town of Saugatuck, and I would have loved to have been able to bring her there.

AUG **MICHIGAN**

SAGATUK

Great Lakes Splendor

Preface

As a young child I became interested in art, and I explored many different types of arts and crafts throughout my school years. I eventually went on to pursue a B.F.A. degree in painting at the University of Colorado. In my last year at CU I began to delve into photography. Learning to do my own darkroom work greatly expanded the possibilities of the medium for me. In the years after graduation, I immersed myself in photography and gained extensive darkroom experience while I apprenticed at the Denver Art Museum's Photography Department.

Photography is a technical art medium that is fascinatingly diverse. I am continually drawn to explore the alternative processes that reveal the human hand at work. For me exposing the image onto photographic film is simply the beginning of the creative journey.

By accident I discovered that Polaroid Time-Zero film could be physically manipulated. I immediately saw the semblance to painting and was entranced that I could physically interact directly with the photographic emulsion. With some research and many boxes of film, I discovered that I could blend colors, create textures, and etch lines. I learned to "paint" with the Time-Zero film emulsion, and the resulting images revealed a captivating ambiguity and duality between photography and painting, realism and impressionism. It became the perfect medium for me. I have now been working exclusively with the process for 20 years.

I have lived in Michigan for 10 years but had never had the opportunity to visit the villages of Saugatuck and Douglas, and it was challenging to approach a subject of which I really knew very little. I initially did research through travel guides, the Internet, and friends who had been there. Then my husband and I hopped on the Harley and went for our first visit.

My first impression was that this is a clean and neat place where people take pride in their homes and environment, yet there is also a quirky edge to it that reveals individuality. Visual surprises are around every corner. It is a vacation destination, yet there is very little of the touristy things that can so often spoil the ambiance of that type of town. We spent several days there, and I returned again several weeks later for another visit.

I then began the intense work of editing and manipulating the hundreds of photographs I had taken. While it is difficult to capture the core identity of an area in just these few images, I hope that you will find in the book the spirit and essence of the villages of Saugatuck and Douglas.

Cynthia Davis

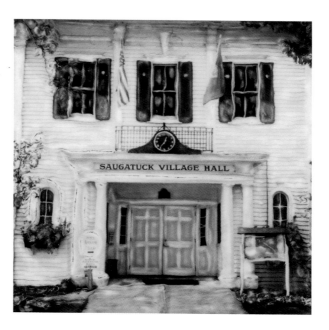

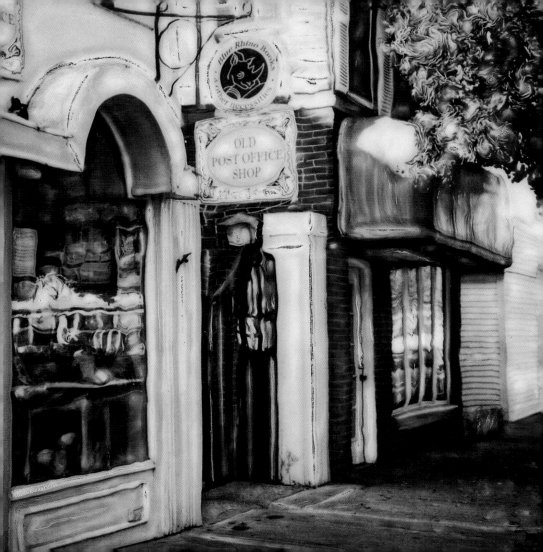

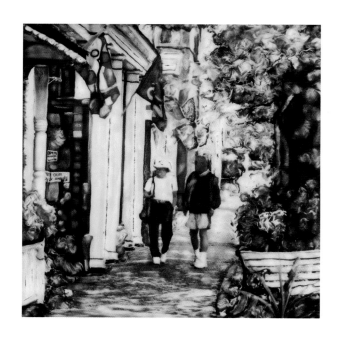

2

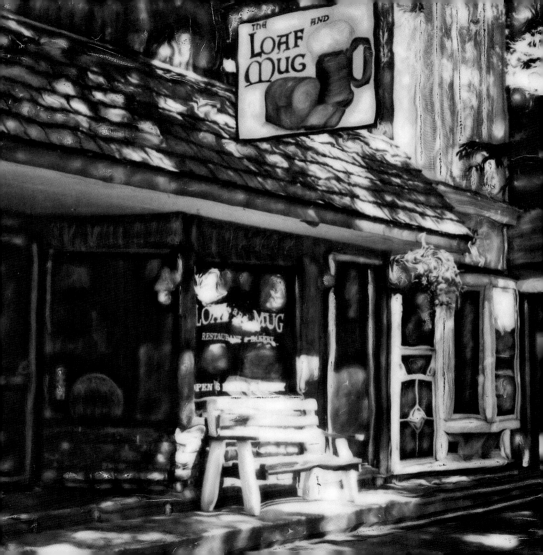

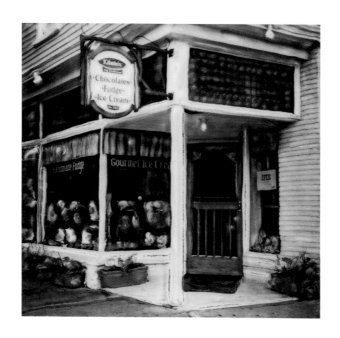

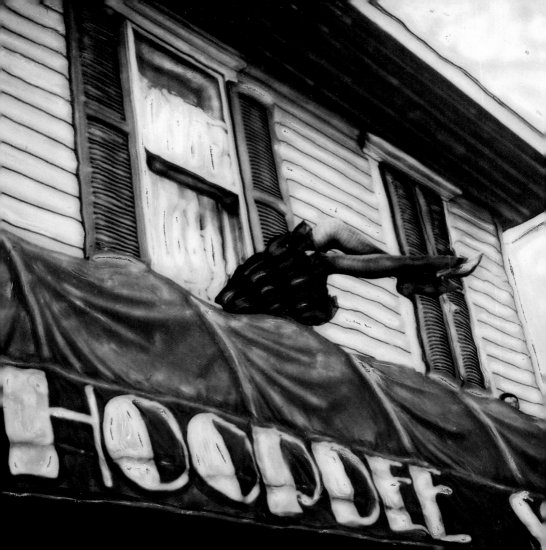

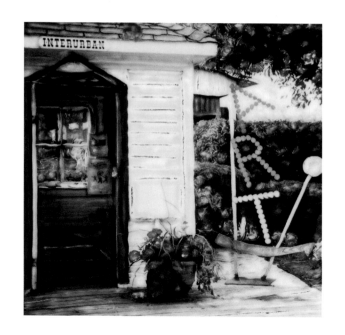

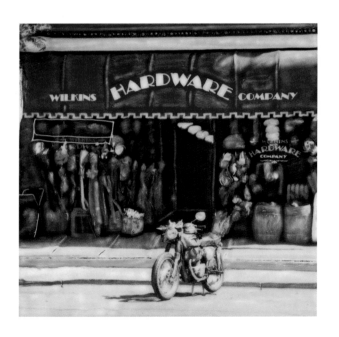

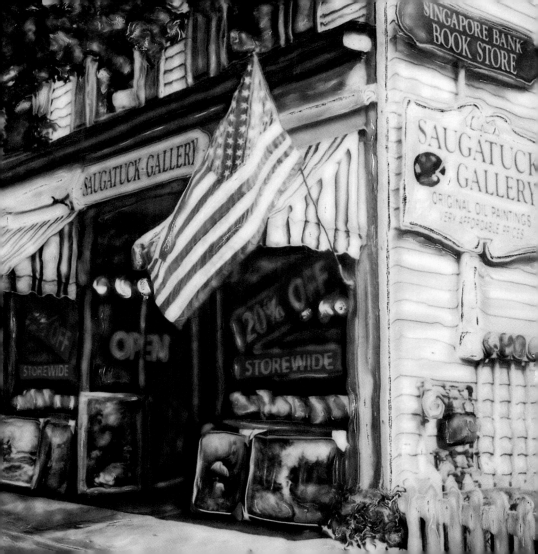

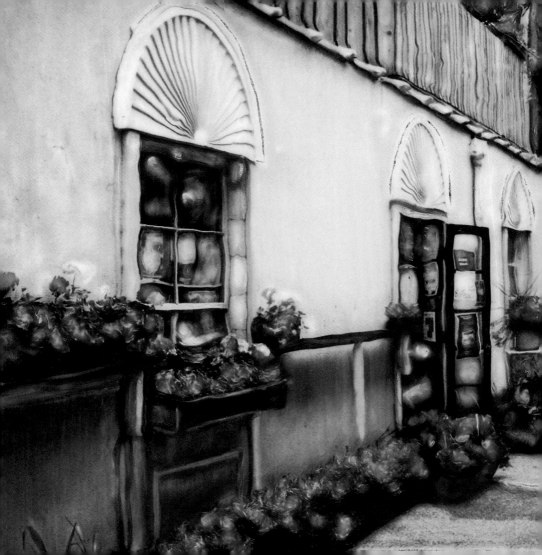

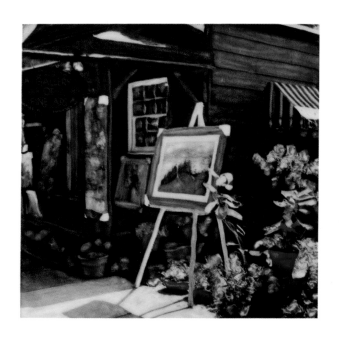

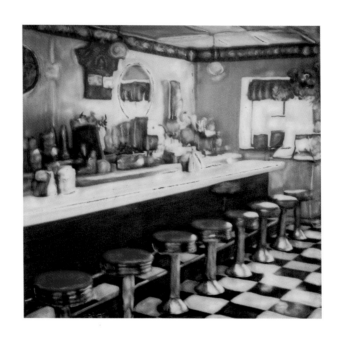

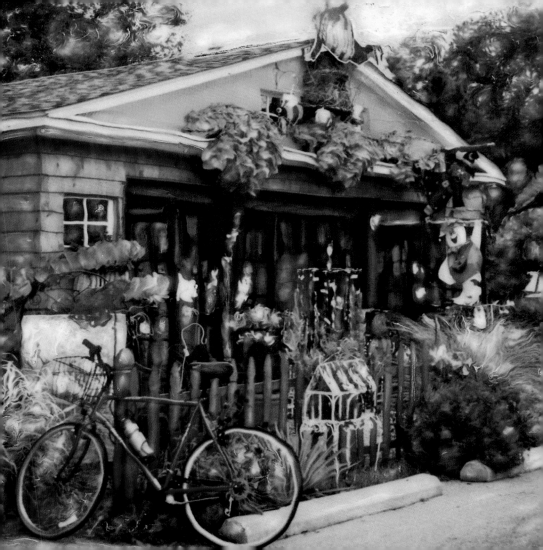

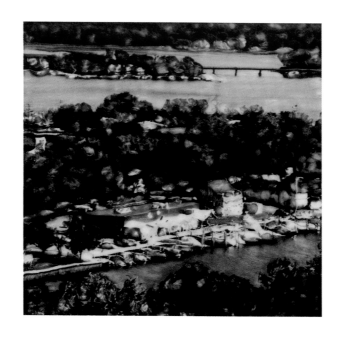

14

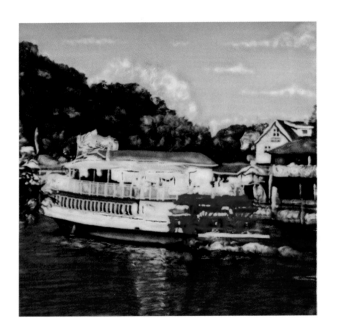

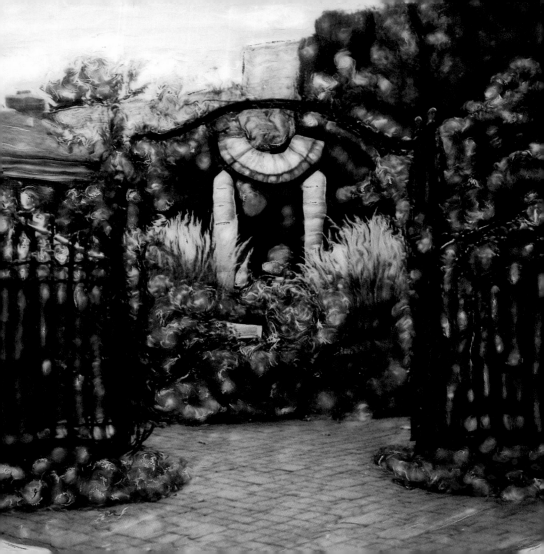

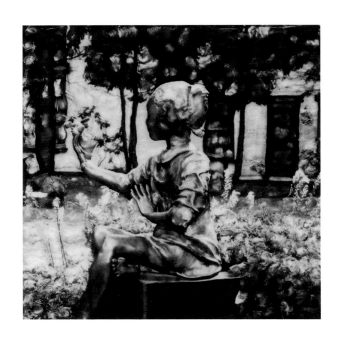

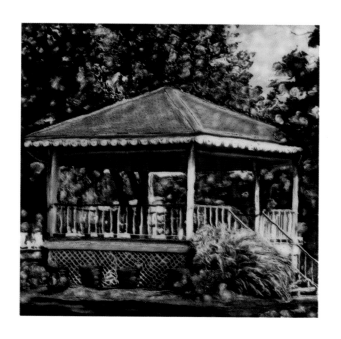

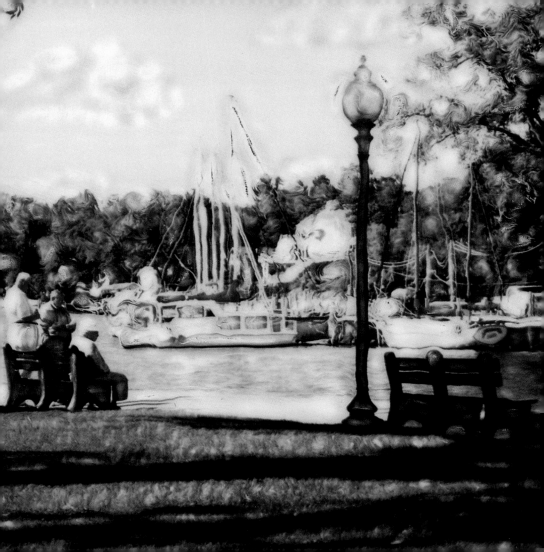

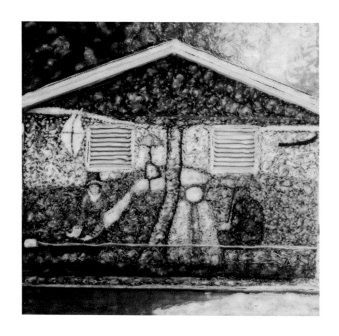

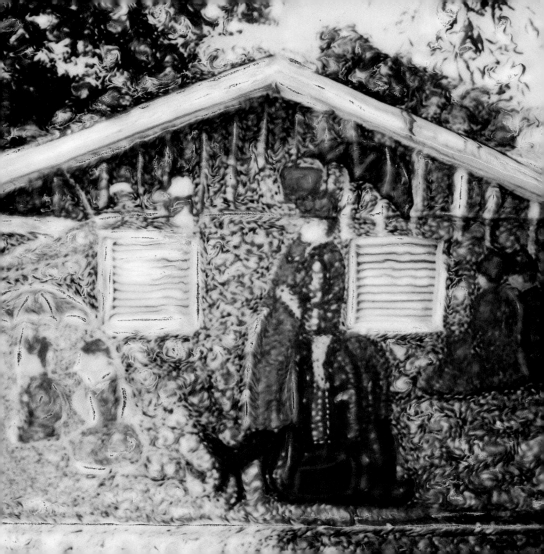

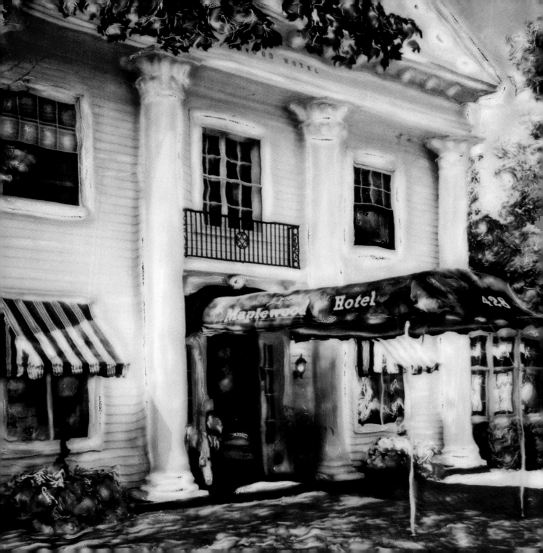

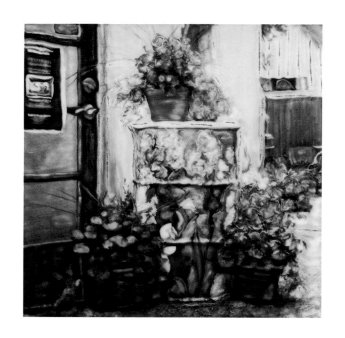

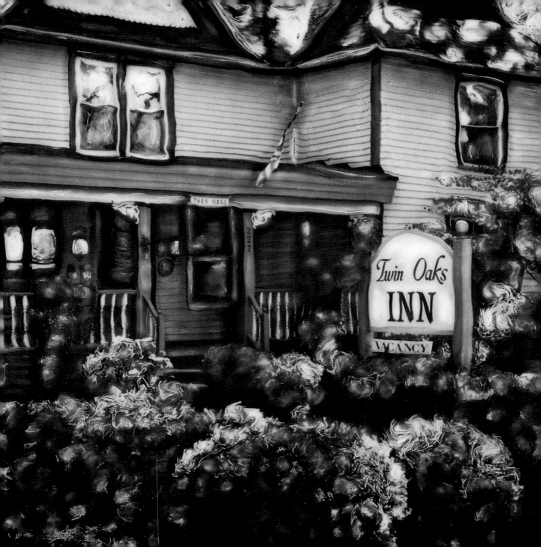

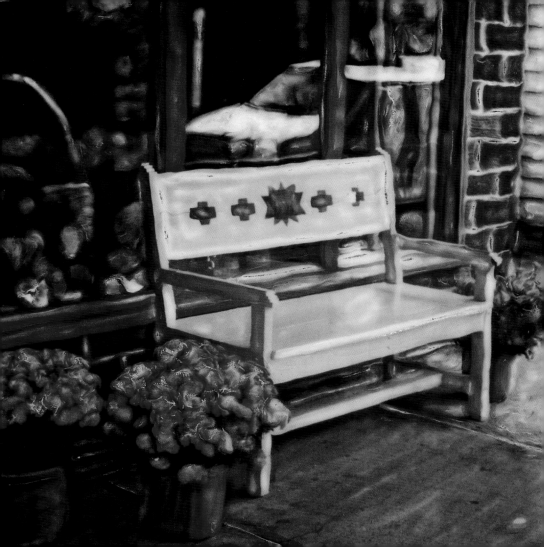

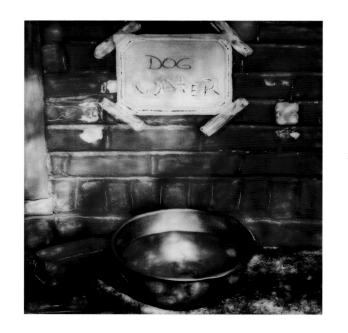

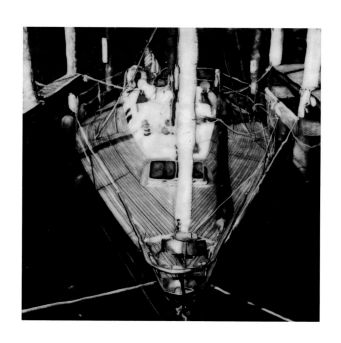

28

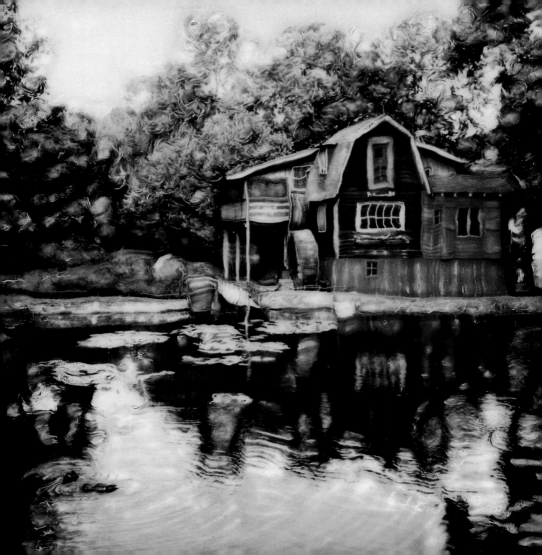

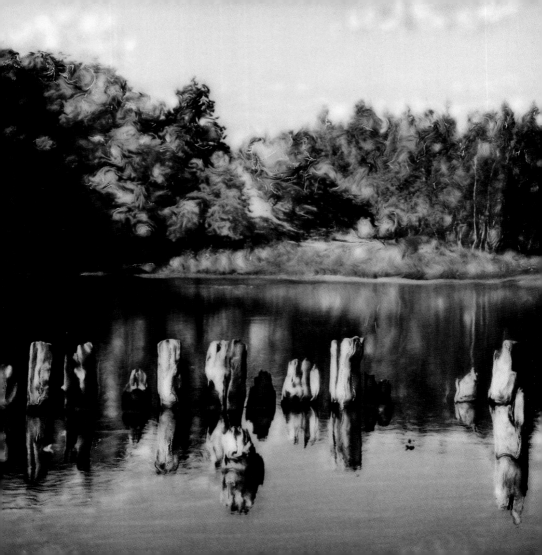

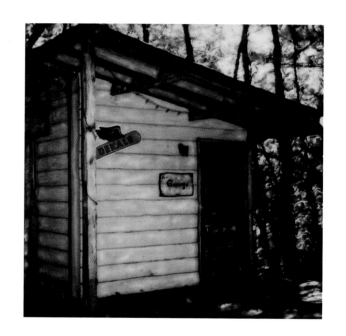

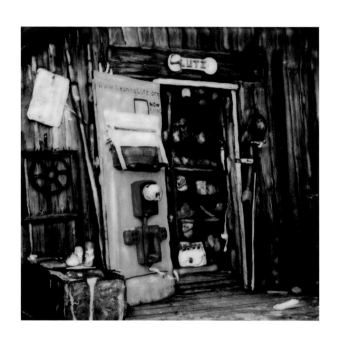

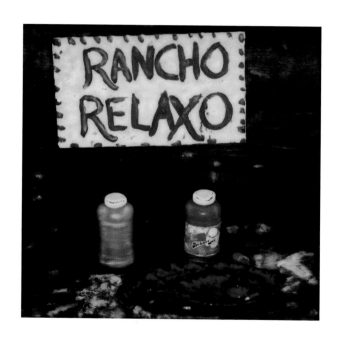

33

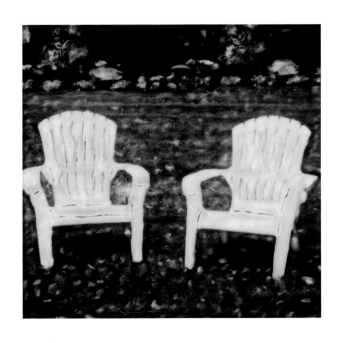

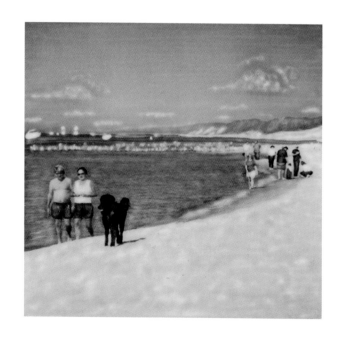

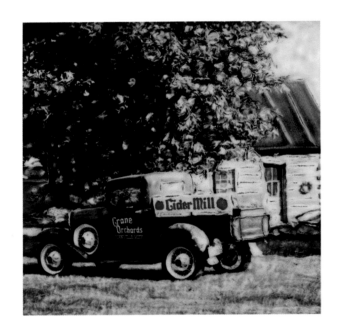

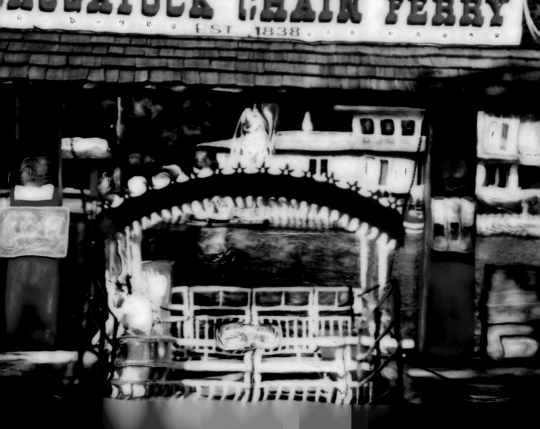

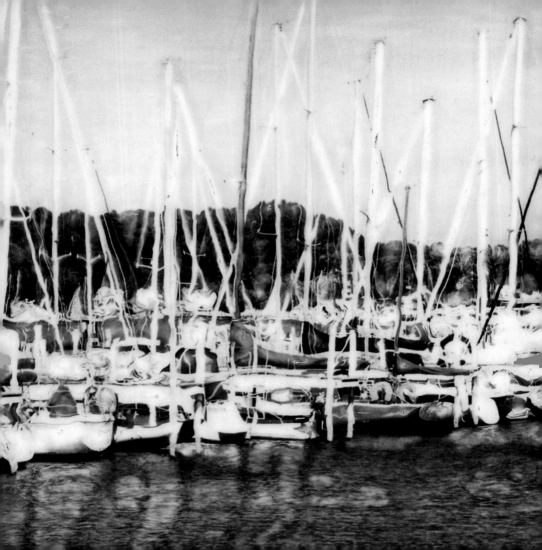

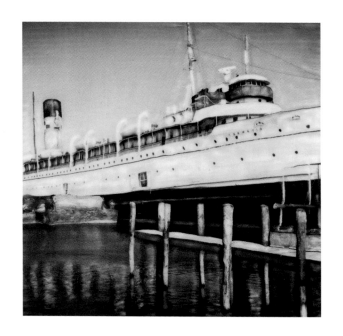

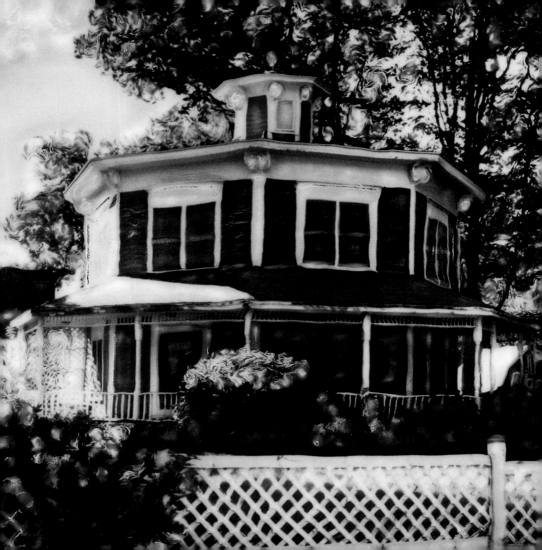

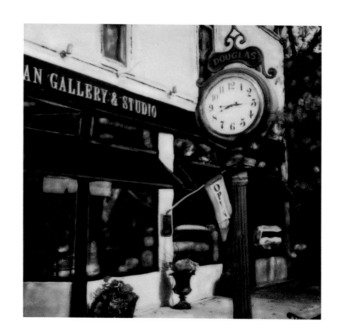

41

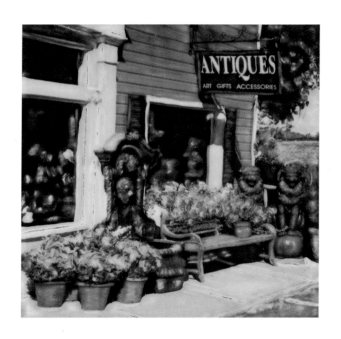

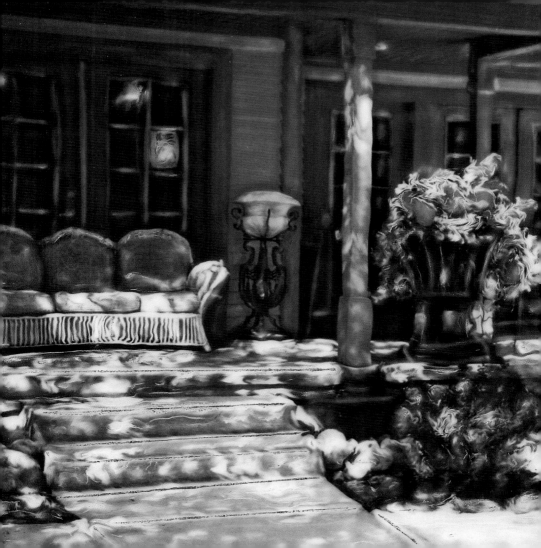

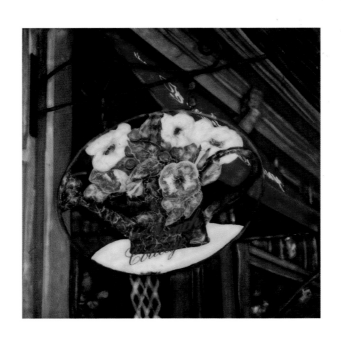

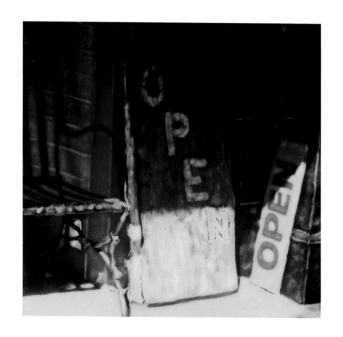

45

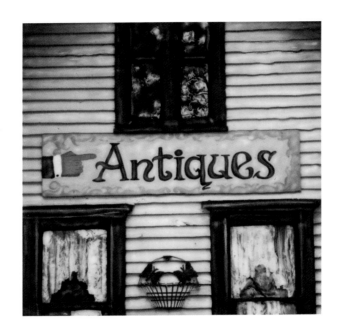

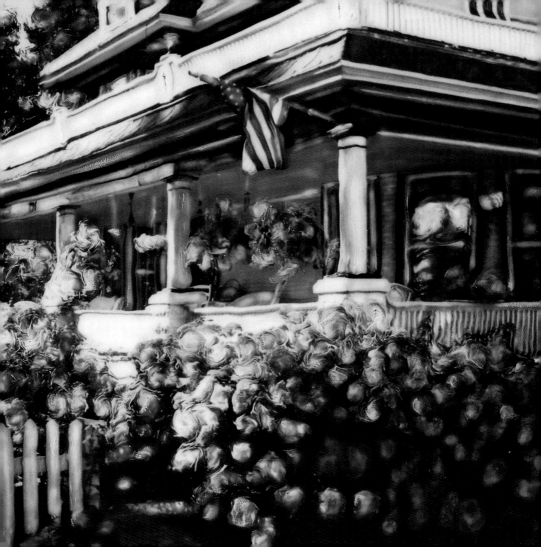

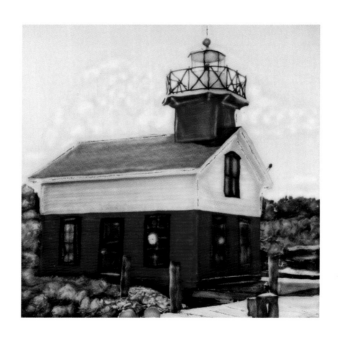